RSA:NC

RSA NEW CONTEMPORARIES

17 MARCH - 11 APRIL 2012

The Royal Scottish Academy has a proud tradition of promoting excellence in contemporary art in Scotland. Led by eminent artists and architects we support the creation, understanding and enjoyment of the visual arts through exhibitions, artist opportunities and related educational talks and events. Re-establishing ourselves as a leading organisation for the visual arts in Scotland, we have successfully garnered a reputation for the strength of our engaging and diverse exhibitions and the fantastic opportunities we offer both established and emerging artists.

Published for the exhibition at
The Royal Scottish Academy of Art & Architecture
The Mound, Edinburgh, Scotland, EH2 2EL
www.royalscottishacademy.org

Exhibition Sponsor

TURCAN CONNELL

LEGAL • WEALTH MANAGEMENT • TAX

CONTE

INTRODUCTION

GLEN ONWIN RSA, EXHIBITION CONVENOR

The task of the convenor and the curating team is to make an exhibition of works of recent artists chosen from the degree exhibitions of the five degree awarding art schools in Scotland. This is the fourth *RSA New Contemporaries* exhibition to be held in the RSA.

The first thing is to see the work; this has to be done within the relatively restricted time schedule of degree shows and involves a bit of planning, and concentrated travel. Firstly Duncan of Jordanstone College in Dundee, then Edinburgh College of Art, next Glasgow School of Art, Moray School of Art in Elgin then Gray's School of Art in Aberdeen. The numbers chosen from each institution are generated by a strict numerical formula based on the numbers of students in the final years. We were able to select one student from every eight graduating. This year's numbers were slightly greater due to course changes and a general increase in student numbers. Dundee 12, Edinburgh 17, Glasgow 13, Moray 2, Aberdeen 9; in addition, 9 graduating students were chosen from the schools of architecture in Scotland. The architecture convenor and deputy convenor of the exhibition this year is Kathryn Findlay RSA.

The interesting times then begin, making choices from a huge range of talent, diversity and energy. Thankfully this task is not done independently; academic staff advise, and for each venue the convenor has a fellow selector who is also an academician. As you look at the work, ideas flood through your mind, wandering from space to space concepts build and then disappear, ideas relate, form themes and then collapse. Of course this is not what you are supposed to be doing, nor what you have been asked to do. We are not making a themed exhibition, but patterns do mysteriously emerge and themes do surface. Individual show after individual show gradually build and reveal a picture of a year group; different areas of study collide and reflect each other, common ideas or fragments of ideas speedily emerge and as quickly evaporate.

Subject matter, or what underpins the research interests of the graduating students, provides a fascinating insight into this precise moment in time. From this cohort dominant areas of exploration include the study of geopoetics, ecology, globalisation, immigration, the world's finite resources, identity, psychology. The sciences and space are just some of the areas looked into by these artists. Nomadism, travel, ritual, personal histories and place linked with myth, traditional or invented, are also developed in their personal creative worlds. This is of course, in almost every case, accompanied by an exploration of materials, the stuff of art itself, and even the non-visual world of sound is explored. Above all imagination is evident; my sense was that what we were seeing was the flavour of our time, an insight into the concerns of future art or at least the art of now. Interestingly, this flavour most often came from the entire body of work we saw, perhaps synchronistically acting together to reveal a zeitgeist that is sensed rather than self-evident.

We made lists or more accurately, scribbled notes: a name or two, the briefest of descriptions, a rough sketch a doodle, mostly (in my case) indecipherable at the later meeting with the teaching staff when and where the final choice was made. As you leave your first institution it's one down four to go but you have the first group, the foundation on which to build the exhibition. On to the next; at the end of the visits all choices made, debate and concerns forgotten, you have the artists. Occasionally we asked for a specific work to be shown in the exhibition, but in the bulk of cases it is the artist, not the work, who has been selected; we have in fact given the chosen group freedom to respond to the extraordinary spaces within the Royal Scottish Academy building. The curating team are in the hands of the artist; it is most importantly the artists who make this show.

Later in the process submissions are received and, where possible, the new ideas are accommodated. Some practical rules are sent out prior to the submissions but beyond that mostly the artists have total freedom to make work specifically for the exhibition. That said, the curatorial team do expect the submitted new works to reflect in essence the work the curating team saw in the degree shows - it is after all only a few months on from graduation. After scrutiny of the submissions and impossibilities noted and communicated back to the artists, the show is very roughly placed, dark spaces, electrical power sockets, sound interference and sightlines considered, the practicalities resolved and most requests, where possible, accommodated.

All this however is well before any work is actually in the galleries; the next stage is arranging the show. The RSA's selection team is reconvened, this time as a group, and the fine tuning and actual placing of work begins. What you see in this exhibition is the result of an amazing amount of work by many people. Firstly the artists; my thanks to them and I hope they enjoy this opportunity to make work, possibly for the first time as a truly professional independent artist without the academic demands of an art school course to consider. At this time in a new artist's career difficulties can emerge; resources are often no longer available; state of the art workshops unavailable; computing facilities and quality studio space have perhaps gone; the artist is driven back to their often more basic personal resources. That said they are on route to an extraordinary life long journey as artists. I congratulate them on this exhibition.

I also thank the academic staff from the five institutions for their hospitality, generosity of time at such a busy period within the academic year and for their contribution to this publication. I would like to thank the staff of the RSA, the hangers and administrators - they make the show a possibility, they bring it to reality. I single out the Programme Director Colin Greenslade who takes on the task of the exhibition in its entirety. Colin was my ever present companion and advisor on the trips to the degree show venues and also fielded the many difficult questions and requests from the chosen artists in the run up to the exhibition, helping them in many ways and easing the entire process. Also Alisa Lindsay, the RSA's Programme Coordinator, for her data gathering skills on the trips and her work on the design aspects of the show and accompanying material; catalogue, posters, promotion material etc. I thank my fellow artists and academicians; Kathryn Findlay RSA, Eileen Lawrence RSA, Jackie Parry RSA, Francis Convery RSA and Gareth Fisher RSA for making the selection process and the exhibition installation a most enjoyable and rewarding experience. It would not have been possible without their expertise, skill, sensitivity and knowledge. I would also like to thank Turcan Connell, the exhibition sponsors, without their very generous support the exhibition would not happen.

Finally to you the viewer: I hope you enjoy the exhibition and the range of work and ideas presented. The *RSA New Contemporaries* is an annual snapshot of the art which is emerging from our great Scottish art schools, they are the hotbeds of this nation's creativity, long may they flourish. I have found the experience of convening the *RSA New Contemporaries* of 2012 at times daunting but always inspiring and exciting. I hope you, as viewers, are equally excited and inspired by the exhibition. You will find thought provoking, challenging ideas, humour and beauty. Artists thrive on others' seeing and knowing their art, tell your friends and bring them to see this extraordinary and vital range of new works by new artists.

EXHIBIT

SELECTED FROM THE 2011 DEGREE SHOWS

FINE ART DUNCAN OF JORDANSTONE COLLEGE OF ART & DESIGN

Lisa Jane Birch
Suzanna Jennifer Clark
Daniel Cook
Aimée Henderson
Rose Hendry
Hannah Imlach
Holly E. Keasey
Claire McDonald
Emma McGregor
Neil Nodzak
Louise Pearson
Claire Reid

FINE ART EDINBURGH COLLEGE OF ART

Rachel Barron
Olivia Crocker &
Elizabeth Hurst
Manuela De Laborde
Clare Flatley
Rosamund Garrett
Sarah Hardie
Andrew Mason
Mike McCallum &
Tommy Stuart
Hannah Grace May Miller
Georgina Parkins
Stacey Strachan
The Creative Services of
Hugo de Verteuil &
Ian Rothwell
Rachael L. Thomas
Claire Wilson

FINE ART GLASGOW SCHOOL OF ART

Eszter Biró
Hannah Brackston
Jonathon Cottrell
Aelfred de Sigley
Romany Dear
Tom Hatton
Zara Idelson
Emilie Lundstrøm
Amy Malcolm
Michelle Roberts
Timothy Savage
Mary Stephenson
Eva Ullrich

FINE ART GRAY'S SCHOOL OF ART

Lindsey Clark
Hannah Harkes
Marion Leiper
Joanna Lyczko &
Seila Susberg
Heather Pugh
Sophia Katie Scott
Susannah Stark
Chris Wells

FINE ART MORAY SCHOOL OF ART

Marnie Keltie
Deborah MacVicar

ARCHITECTURE DUNDEE SCHOOL OF ARCHITECTURE

Luca Di Somma

ARCHITECTURE EDINBURGH COLLEGE OF ART

Scott Licznerski

ARCHITECTURE THE EDINBURGH SCHOOL OF ARCHITECTURE & LANDSCAPE ARCHITECTURE (ESALA)

Sarah Clayton & Gillian Storrar
Andrew Morris

ARCHITECTURE MACKINTOSH SHOOL OF ARCHITECTURE

Martin Flett

ARCHITECTURE SCOTT SUTHERLAND SCHOOL OF ARCHITECTURE & THE BUILT ENVIRONMENT

Daria Byra
Rowan Morrice

ARCHITECTURE UNIVERSITY OF STRATHCLYDE

Abigail Benouaich

DUNCAN OF JORDANSTONE COLLEGE OF ART & DESIGN

UNIVERSITY OF DUNDEE

FOREWORD BY MOIRA PAYNE

ARTISTS

Lisa Jane Birch

Suzanna Jennifer Clark

Daniel Cook

Aimée Henderson

Rose Hendry

Hannah Imlach

Holly E. Keasey

Claire McDonald

Emma McGregor

Neil Nodzak

Louise Pearson

Claire Reid

DUNCAN OF JORDANSTONE COLLEGE OF ART & DESIGN

MOIRA PAYNE, DIRECTOR, ART AND MEDIA
(FINE ART, ART PHILOSOPHY & CONTEMPORARY PRACTICES, TIME BASED ART & DIGITAL FILM)

Where is the new public imagination?

Steeped in cultural production and the social hierarchy of the consumer, or more likely, the imperatives of the social critique. Art schools tread the path between the current educational paradigms. On the one hand we equip students to understand social cultural values, to reflect and engage, to continuously position themselves within a context that Paul Gaultier would describe as "the good, the true and the useful" and on the other we promote and celebrate the creative spirit that must be beholden to none. With the new patrons of the arts taking the form of Research Funding Councils and universities measuring success in graduate destinations and career statistics, the words 'creative freedom' are not the first words that spring to mind. In our world of 'ethics' and 'enterprise', young artists could be forgiven for thinking that the days of expression, transcendence and intuitive sensibility were well and truly over.

Yet it is all there..."hope springs eternal," nothing is lost, just as comfortable with the aesthetics of liberation and neo Marxist visual economies, our young artists find ways of individually picking and gathering through the fertile grounds of contemporary practice. Duncan of Jordanstone is the art school that leads visual research in Scotland and what a frontier town this is: New Knowledge Exchange, Research, Art and Science, Art and Philosophy, Public Art and Audience, our students and staff relish the border crossings that make an art school within a university a healthy vibrant place to be. Amongst our talented 2012 New Contemporaries listed below we have Artist Film Makers, Artist-Philosophers, and Fine Artists, all sunited within the Art and Media Group.

Lisa Birch writes what she cannot say out loud. The intricacies and visual power of the written word, text as image, her language work paints an image and the subtle use of a fine liner pen whispers important things. Things about isolation and frustration, Lisa draws you into her intense, quiet communication.

Suzanna Clark uses video, print, sculpture and text, she writes: "Our own perception, which is integral to our understanding of the world around us, is defined by an intriguing biological design. The fundamental basis of our vision relies on two aspects, darkness and light. Our eyes continually moving in a series of jumps devise our perceived view of the world around us. In between each jump is a millisecond of black where we are literally blind to our exterior surroundings. Everyday these black intervals amount to around 90 minutes of visual blindness".

Daniel Cook bases his work on a series of photographs taken in Wester Ross in the Highlands of Scotland, a landscape that bears testament to a turbulent history. Danny examines the impact that human intervention has had, on both a visual and an emotive level, upon our perceptions of the landscape of Scotland. The work focuses on engaging the ambiguity between reality and fiction. Photographs of the local landscape, the abundance of abandoned structures and materials relating to human intervention provide backdrops for characters and objects, which appear to be out of place and time within the composition. The prints represent a narrative snapshot of a different era.

Aimee Henderson shifts between the conscious and the subconscious, her small painterly compositions rely on those small material shifts, marks and colours that offer an intimate contemplative space.

Rose Hendry writes of her work; "I aspire to create films that are cinematic, have a high production value and employ experimentation and creativity. I am a committed filmmaker and wish to work in a range of film disciplines including narrative, commercials, music videos and artists' film. I enjoy creating short, cinematic works that employ the language of cinema and use the autonomous language of commercials. I like the elegance of commercials and the grubbiness of ordinary domestic living. Through the combination of these visual elements I wish to achieve visually interesting, poetic and beautiful films".

Hannah Imlach writes of her work, "I am interested in the nature of our interaction with the environment and work in constant reference to the landscape, focusing on how a piece of art may be involved in the simplest yet most overlooked experiences. Investigating our relationship with the natural elements, I created a shelter in which to explore the subtle changes in natural light that are so dramatic over the Scottish landscape and a jacket with a shell-shaped origami hood for a heightened sensorial encounter with the rain. These objects suggest the presence of an alternative dweller with a shifted ecological perspective, a futuristic vision of a more nomadic, uninhibited and sustainable existence".

Holly Keasey immerses herself in the story of Edinburgh's water using water bottles collected from around the city to create an installation that also provides a backdrop to a performance.

Claire McDonald's recent work has been based around a specific forest near her family home in Fife. Through her work she explores a forensic view of place. Claire uses raw materials gathered from the land, revealing new views of the place through dissecting trees, focussing on the minutiae of nature, grinding coal and limestone and using sculpted wooden objects as printing and drawing materials.

Emma McGregor explores the industrial heritage of Bradford her hometown using bitumen, iron, oil, brass and wood in order to refer to old industrial processes of the mills and factories of the past.

Neil Nodzak's sculptures evoke a "hypothetical utopia" his architectural references describe failed social constructs.

Louise Pearson has developed a colour code that tracks the lunar cycle whilst simultaneously producing an audio score. The resulting synaesthetic experience provides a complete sensory exploration of the 28 day/night cycle.

Claire Reid writes of her work; "The way plaster, lace and wood describe loss is central to my work. The object and the inherent narrative contained within the material has been a way for me to express distance and longing. A small crack in plaster, a ring in un-primed wood, this is where my biography lies, this is how I describe the loss of my father. The poetry in my work can undermine the pragmatics of process, the pleasure in making and construction must not be lost in the fragility of lace. My work preserves the memories that I do not want to forget".

LISA JANE BIRCH

GRADUATED: DUNCAN OF JORDANSTONE COLLEGE OF ART & DESIGN

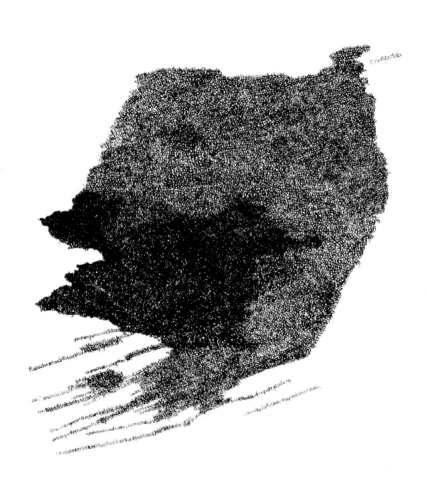

Untitled 2011 (detail) [2011] Fine-liner pen on paper 110 x 146 cm

SUZANNA JENNIFER CLARK

GRADUATED: DUNCAN OF JORDANSTONE COLLEGE OF ART & DESIGN

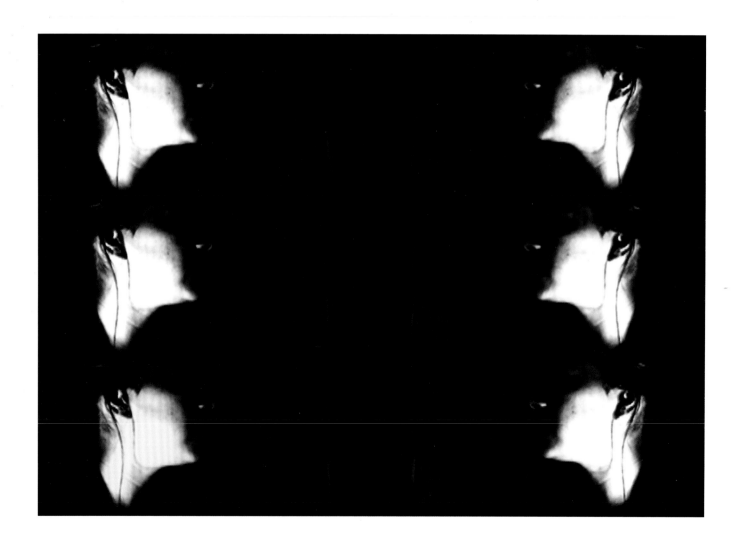

Speech [2011] Digital film, 20 x 14.18 cm

DANIEL COOK

GRADUATED: DUNCAN OF JORDANSTONE COLLEGE OF ART & DESIGN

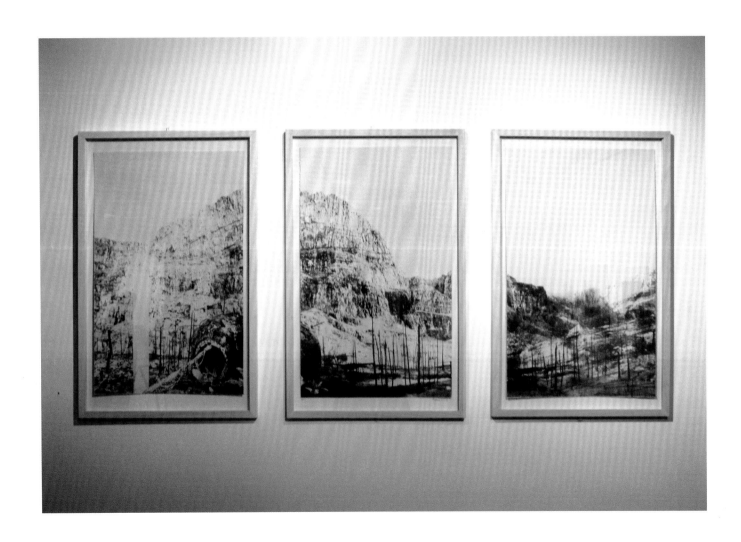

66 Bomber Squadron [2011] Lithograph. 70 x100cm.

AIMÉE HENDERSON

GRADUATED: DUNCAN OF JORDANSTONE COLLEGE OF ART & DESIGN

Untitled [2012] Oil on paper, 18.5 x 18.5 cm

ROSE HENDRY

GRADUATED: DUNCAN OF JORDANSTONE COLLEGE OF ART & DESIGN

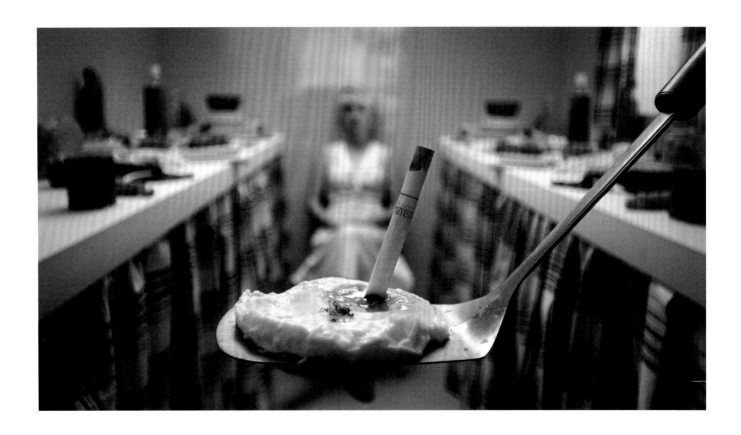

Still from *Egg & Fag* [2011] Artists film

HANNAH IMLACH

GRADUATED: DUNCAN OF JORDANSTONE COLLEGE OF ART & DESIGN

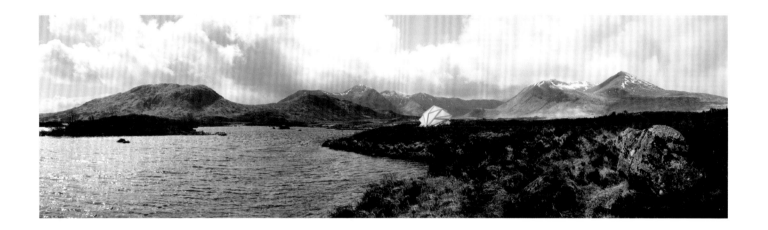

Origami Shelter at Rannoch Moor [2011] Limited edition digital print, 300 x 87cm

HOLLY E. KEASEY

GRADUATED: DUNCAN OF JORDANSTONE COLLEGE OF ART & DESIGN

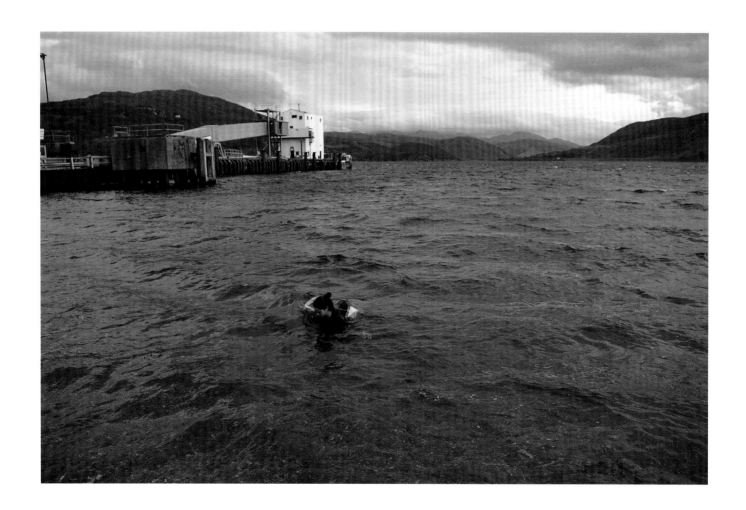

47 Bottled Seas, Documentation of Live performance, Ullapool Harbour [2011] 30 minutes

CLAIRE McDONALD

GRADUATED: DUNCAN OF JORDANSTONE COLLEGE OF ART & DESIGN

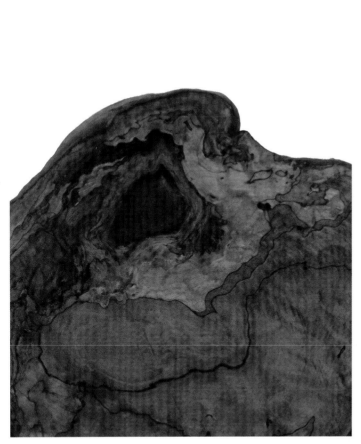

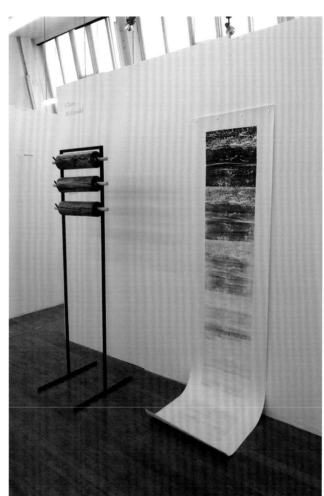

Images from left: **Beech Slice** [2011] Natural wood, 50 x 70cm
Rollers and relief [2011] Roller stand 180 x 60cm, print 60 x 250cm, metal, natural wood, relief ink on paper

EMMA McGREGOR

GRADUATED: DUNCAN OF JORDANSTONE COLLEGE OF ART & DESIGN

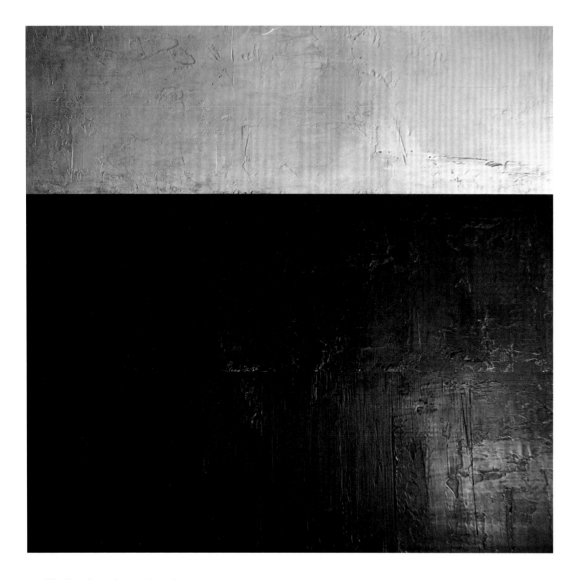

Bradford #1 [2011] Mixed media, 229 x 229 cm

NEIL NODZAK

GRADUATED: DUNCAN OF JORDANSTONE COLLEGE OF ART & DESIGN

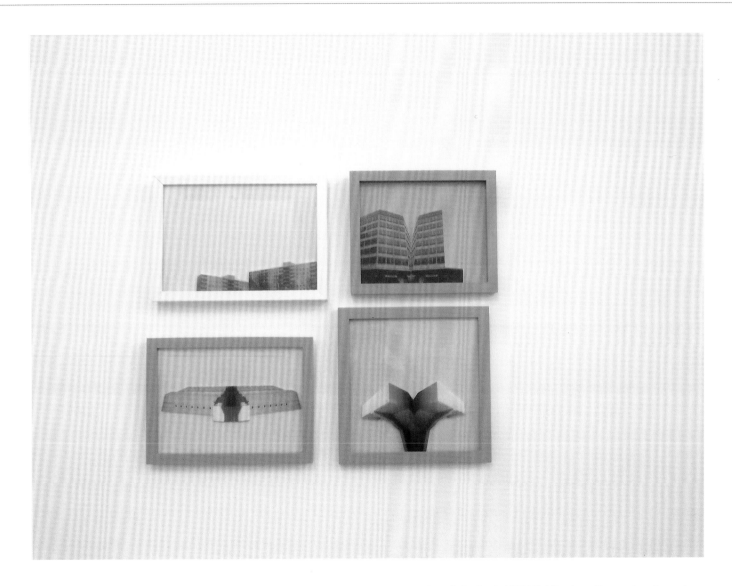

Piryapit Series 1-4 [2011] Mixed media, varying dimensions

LOUISE PEARSON

GRADUATED: DUNCAN OF JORDANSTONE COLLEGE OF ART & DESIGN

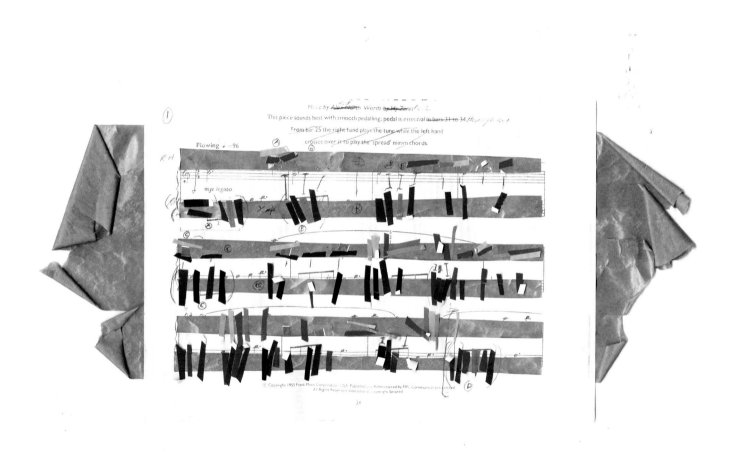

4th March, page 1 [2011] Collage, 42 x 21 cm

CLAIRE REID

GRADUATED: DUNCAN OF JORDANSTONE COLLEGE OF ART & DESIGN

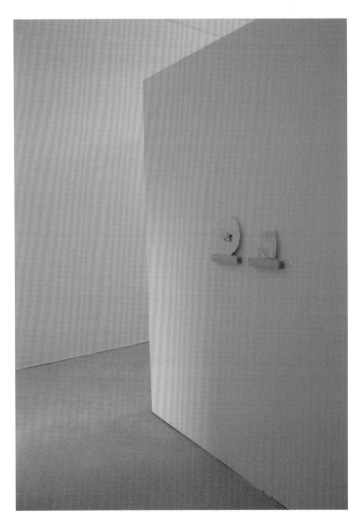 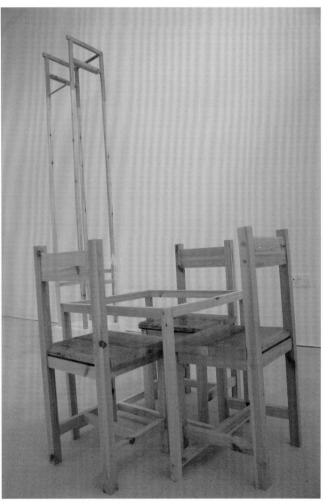

Images from left: **Plaster samples** [2011] Plaster and ink
Table and chairs [2011] Recycled and new wood

EDINBURGH COLLEGE OF ART

FOREWORD BY STUART BENNETT

ARTISTS

Rachel Barron

Olivia Crocker & Elizabeth Hurst

Manuela De Laborde

Clare Flatley

Rosamund Garrett

Sarah Hardie

Andrew Mason

Mike McCallum & Tommy Stuart

Hannah Grace May Miller

Georgina Parkins

Stacey Strachan

The Creative Services of
Hugo De Verteuil & Ian Rothwell

Rachael L. Thomas

Claire Wilson

EDINBURGH COLLEGE OF ART

STUART BENNETT, HEAD OF THE SCHOOL OF ART

The Greek word *chorobate* translates as 'treading over regions'. A *chorobate* is an ancient builders' instrument used to measure perpendicularity; a twenty-foot long beam supported by two legs with a channel in the top of the beam that is filled with water. Plumb lines hang from it to find a level between two points when planning and surveying. An elegant oversized spirit level with a groove for use as a sightline; it was used to level the Roman aqueducts. The plumb and level verticality is detached from topographical differences.

RSA New Contemporaries is a measure of the landscape of artists graduated from Scottish art colleges. To establish the level a device called RSA *Team* is used. It has three core elements; two key selectors, one with a convenor role and one regulator. Localised and specialist bolt-ons are added while the RSA *Team* treads the regions' degree shows. The convenor assembles the device, calibrates it and gauges the varied output. A scope of things is selected, then there is a break while some of the work gestates, some is generated, some fixed or polished.

Sentences about image, object and intention are collated from the artists; *a monumental structure without the conventional dictated focus using prescribed formulas to place physical components interested in public art that stands against the rigidity of mainstream object-histories themes such as the cosmos, human beings' existential concerns and spectacular landscapes we seek to provide prompt and practical solutions to any received or perceived problems within the cross-dynamic flows of the creative and culture industries develop processes of solidifying distortions and reflections of the familiar processes of framing, constraining and categorizing a position that was discordant to the architectural features of the space not even consciously notice these calls but that's the whole point: rejecting or accepting the call of the other grand setting it will heighten this transformation from function object to aesthetic ornament*

..... the flow of people around the device will provide the stimulus for self-produced content visual languages throughout history architecture with visible signs of decay suggestion and manipulation of the horizon abbreviate an otherwise complex landscape history behind the surfaces I reclaim old technologies sculptures pinned and hung on the wall and potentially ceiling Google search provides the paranoiac user with a flat plane of imagery work to be of a site-adjusted nature, with dimensions determined by the architectural characteristics of the space anthropogenic environments dealing with the disposal of a harmful by-product creativity as important stimuli and vehicles for personal and community development and positive social change..... and printed matter like this catalogue is developed as a benchmark memorial of the exhibition.

The Scottish Academy was an artist led initiative founded by 18 artists living and working in Edinburgh in 1826. Through Royal Charter in 1838 it became the Royal Scottish Academy and in 1850 Prince Albert laid the foundation stone of the new building on the Mound. In 1911 art exhibition and education were separated and the teaching and learning moved to Edinburgh College of Art while the RSA focused on supporting and exhibiting artists. This group of artists are the last to graduate from Edinburgh College of Art as an independent institution. A college from an academy generated through artist led ambition, spirit and resourcefulness that has a continuing record of graduates instigating artist led activities and spaces.

All of this highlights the mutating, evolutionary and often cyclical nature of education and exhibition but, essentially, focuses on initiatives led by artists. Whatever structure or configuration the place of education or exhibition takes, the visual acuity and reification of imaginative responses from those engaged in these consortia take precedence. As conditions change thoughts and statements like the ones

listed above persist. Deliberately unattributed, they don't aid an understanding of how or why the work exists in the form it takes, but do point to a response to history, environment and, of course, context.

The RSA *Team* device, to find a balance of work from the recent crop of graduates and situate it in the galleries, is more instinctive than systematic. *RSA New Contemporaries* provides a pragmatic situation for artists across Scotland to exhibit together, to be social and to look forwards. The *chorobate* finds a level between two places but perhaps its most important feature is the groove that acts as a sightline to see where another point could be, to imagine what might materialise and to anticipate the next stage of transformation........and that is unmeasurable.

RACHEL BARRON

GRADUATED: EDINBURGH COLLEGE OF ART

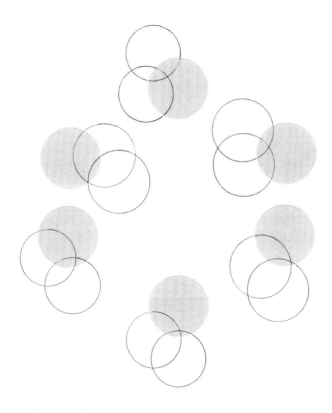

A notational response [2010] Mixed media, 21 x 14.8cm

OLIVIA CROCKER & ELIZABETH HURST

GRADUATED: EDINBURGH COLLEGE OF ART

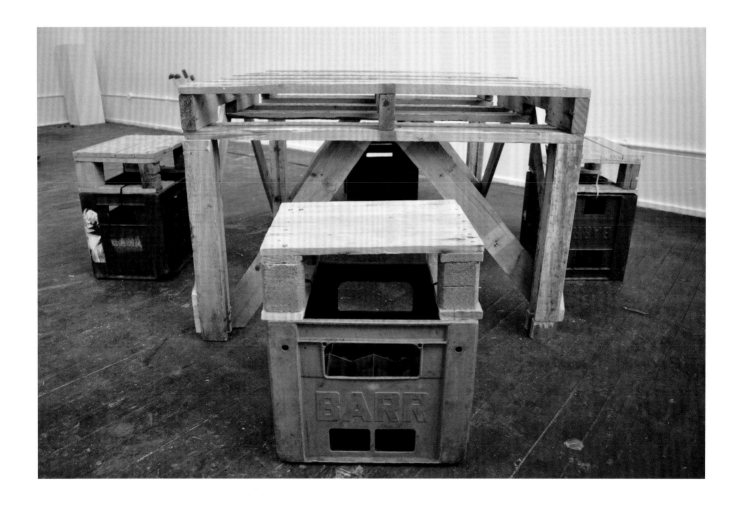

Four Course History [2011] Pallet and crate installation and accompanying audio guide

MANUELA DE LABORDE

GRADUATED: EDINBURGH COLLEGE OF ART

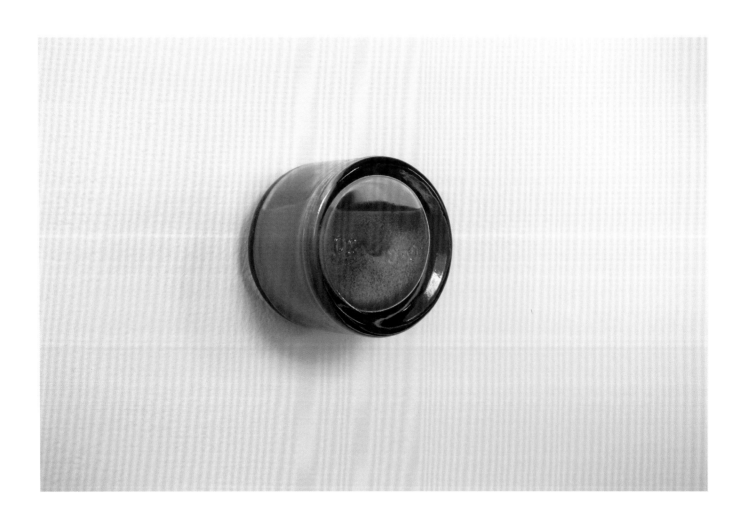

Untitled (Turning Gold Ink) [2011] Gold ink pot and rotating motor, dimensions variable

CLARE FLATLEY

GRADUATED: EDINBURGH COLLEGE OF ART

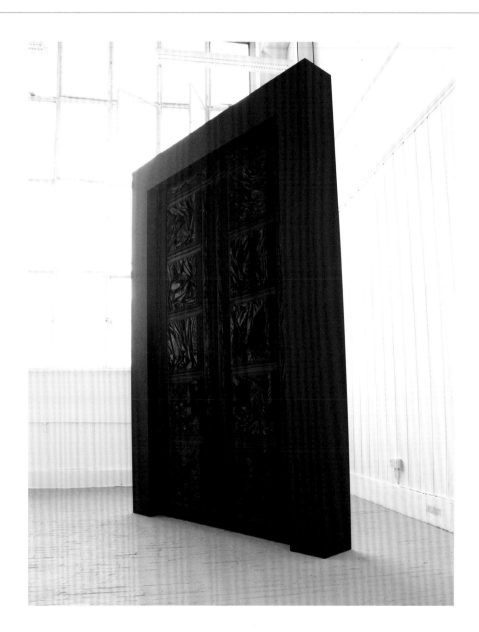

The Black Gates [2011]
Jesmonite, MDF
3.5m x 2.5m x 0.3m

ROSAMUND GARRETT

GRADUATED: EDINBURGH COLLEGE OF ART

The Nao Victoria
Commercial Flight
Internet Data Flow

Virtually Nao [2011-2012] Animated Wall Mural

SARAH HARDIE

GRADUATED: EDINBURGH COLLEGE OF ART

I'm calling; can you hear me? [2011] Video still, shot by Lukasz Kulec

ANDREW MASON

GRADUATED: EDINBURGH COLLEGE OF ART

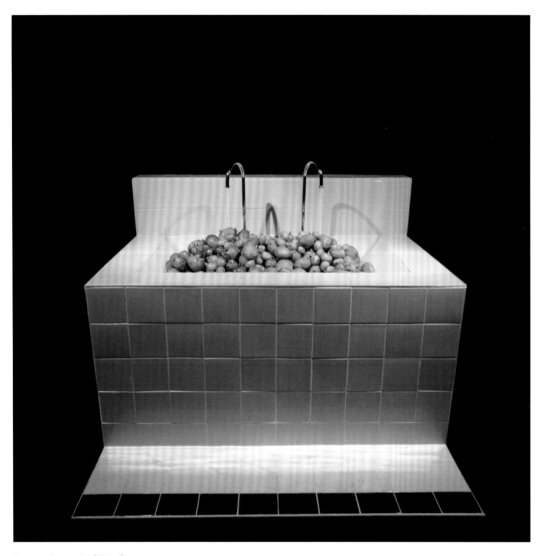

Potato Fountain [2011]
Potatoes, water, chrome swan neck taps, white and black ceramic tiles, black carpet underlay. 140w x 150d x 105cm

MIKE McCALLUM & TOMMY STUART

GRADUATED: EDINBURGH COLLEGE OF ART

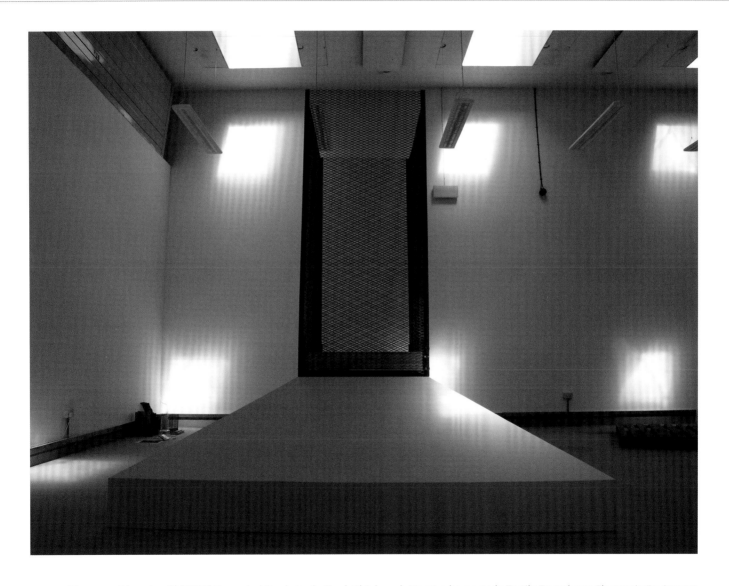

Monument (version 1) [2011] Expanded Steel, Angle Steel, Chipboard, Massive homemade Tactile Transducer, Electronic Equipment

HANNAH GRACE MAY MILLER

GRADUATED: EDINBURGH COLLEGE OF ART

Searching For Something (detail) [2011] Screen print

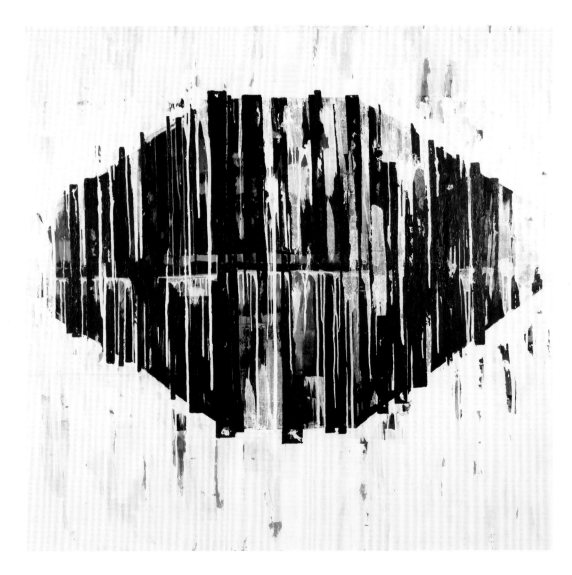

A Study of The Forth Bridge [2011] Acrylic and oil on canvas, 175cm x 175cm

STACEY STRACHAN

GRADUATED: EDINBURGH COLLEGE OF ART

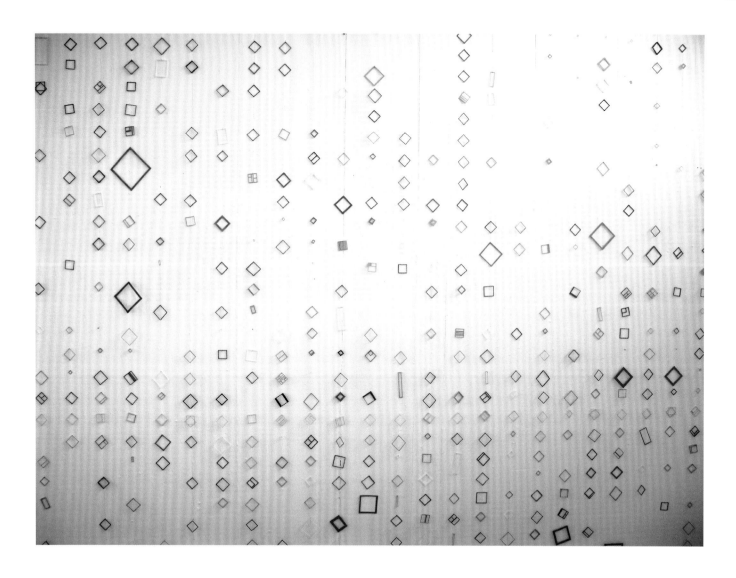

Untitled [2011] Dyed craft matchsticks and foam board. 589cm x 341cm approx.

THE CREATIVE SERVICES OF HUGO DE VERTEUIL & IAN ROTHWELL

GRADUATED: EDINBURGH COLLEGE OF ART

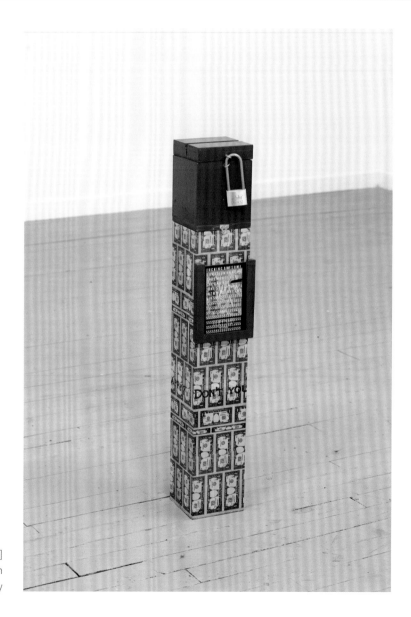

Donations Box [2011]
Mixed Media. 100cm high
Photo courtesy of The Embassy Gallery

RACHAEL L. THOMAS

GRADUATED: EDINBURGH COLLEGE OF ART

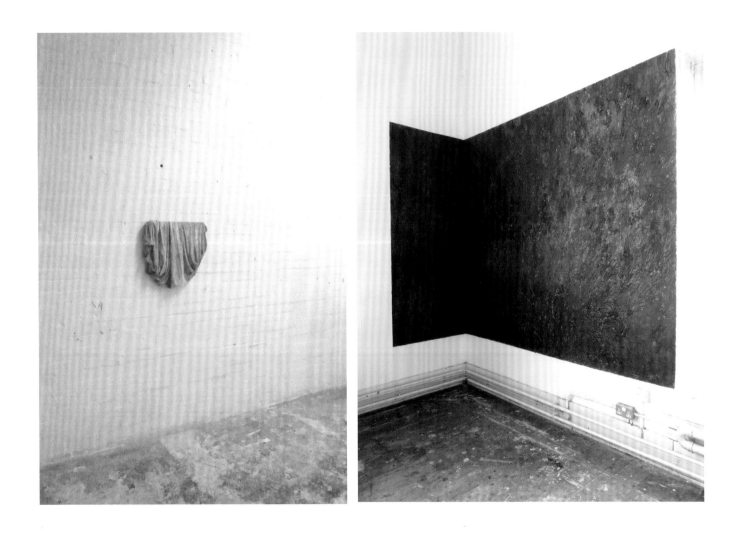

Images from left: **Untitled (Boiler Room)** [2011] Clingfilm, oil paint, flour, thread, wood. 50 x 40cm
Mud Wall [2011] Honey, linseed oil, chalk, flour, gold leaf, charcoal. 2 x 4m

CLAIRE WILSON

GRADUATED: EDINBURGH COLLEGE OF ART

Green Spaces [2010] Anthropogenic Soil. 60 x 60 x 18cm

GLASGOW SCHOOL OF ART

FOREWORD BY STUART MacKENZIE & MICK McGRAW

ARTISTS

Eszter Biró

Hannah Brackston

Jonathon Cottrell

Aelfred De Sigley

Romany Dear

Tom Hatton

Zara Idelson

Emilie Lundstrøm

Amy Malcolm

Michelle Roberts

Timothy Savage

Mary Stephenson

Eva Ullrich

GLASGOW SCHOOL OF ART

STUART MacKENZIE, SENIOR LECTURER, PAINTING AND PRINTMAKING
MICK McGRAW, LECTURER IN CHARGE OF PRINTMAKING

The *RSA New Contemporaries* has quickly established itself as a platform, for recent graduates of Fine Art and Architecture throughout Scotland to show their work in a major venue of considerable historic and contemporary standing. For many years students had enjoyed the opportunity to show in the RSA annual student exhibition, which in itself was a great opportunity for generations of students. The New Contemporaries Exhibition is something quite different and unique, and it continues to accrue momentum each year with students from across Scotland and further afield gaining a growing awareness of its significance.

The notable difference in the format of New Contemporaries is the Academy's decision to move to a selected and curated exhibition. The selection panel visited each of the degree-awarding, art institutions in Scotland at the time of their degree exhibitions and meticulously selected work by graduates, with the consideration of the larger arena of the RSA galleries clearly in view. This rigorous process dealt not only with the work on show, but also reflected on the potential and ambition of each individual, and how they might respond to an invitation to submit a proposal of what they might include in the exhibition.

There has been considerable thought and deliberation in the development of the New Contemporaries Exhibition and how the RSA interfaces with the main art institutions in Scotland.

The Exhibition provides a springboard to the participants at the start of their professional careers; an opportunity that for many, may be the first time their work has been shown as part of a wider, public exhibition, opening new doors and friendships, contacts and networks.. This will undoubtedly influence and shape their experience of exhibiting from here on in. The importance of this experience cannot be underestimated.

Those selected from the Glasgow School of Art are a truly international cohort. The selection includes participants from Scotland, England, Switzerland, Hungary and Denmark. In addition, individuals from this group have worked or studied in the Middle East, North Africa, USA, South India, Czech Republic, France and Norway. Perhaps this drive and ambition was evident in the work observed by the selection panel. Closer inspection of the subject matter, through a cross section of their work, will illustrate some of the polemics engaging many young artists today: political unrest, gender, religion, technology and cultural identity, to name a few.

ESZTER BIRÓ

GRADUATED: GLASGOW SCHOOL OF ART

Distant Gaze, 14 Times [2011] Ink jet archival photo print. Each portrait 27 x 38 cm

HANNAH BRACKSTON

GRADUATED: GLASGOW SCHOOL OF ART

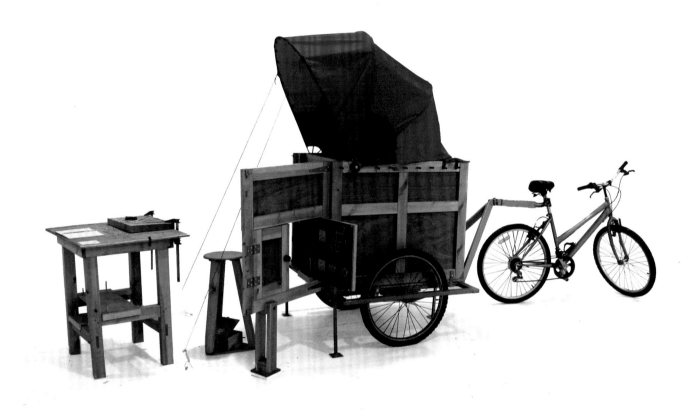

Nomadic workshop [2011] Mixed media (mainly steel, pine and plywood). 450 x 150 x 80cm

JONATHON COTTRELL

GRADUATED: GLASGOW SCHOOL OF ART

Reckless Abandon 3 [2008]
Digital inkjet direct print on 5mm
Forex. 84 x 84cm

AELFRED DE SIGLEY

GRADUATED: GLASGOW SCHOOL OF ART

**Night and Nights in
Themselves are Nothing** [2011]
Ink on Burnished Photocopy
31 x 25cm

ROMANY DEAR

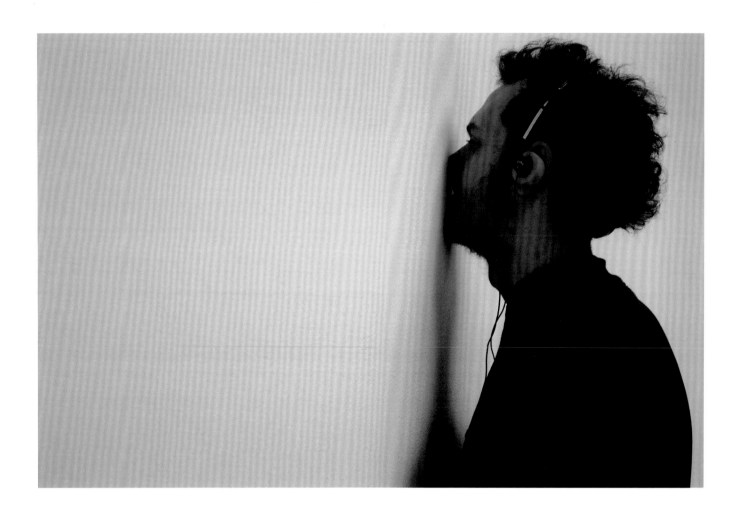

For the next eight minutes I would like to encourage you to fully embrace absolutely everything [2011]
Audio Installation, Glasgow School of Art Degree Show 2011

TOM HATTON

GRADUATED: GLASGOW SCHOOL OF ART

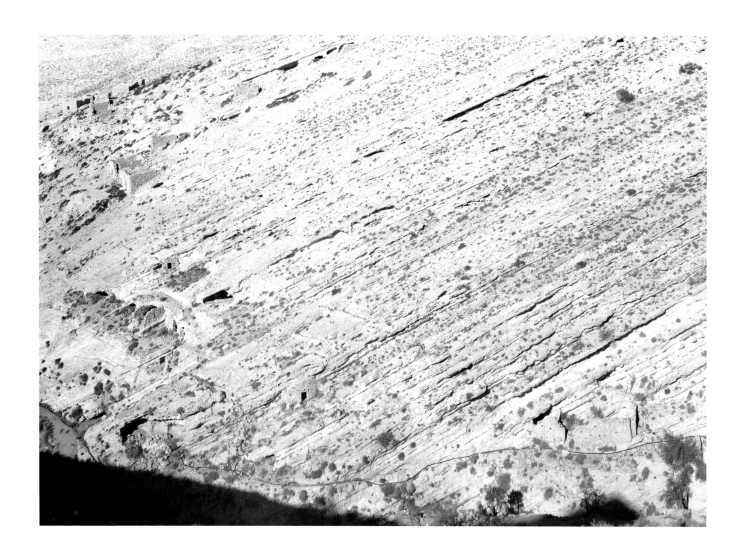

Kings Highway, Jordan [2011] Black and White Silver Gelatine Print. 56 x 41cm

ZARA IDELSON
GRADUATED: GLASGOW SCHOOL OF ART

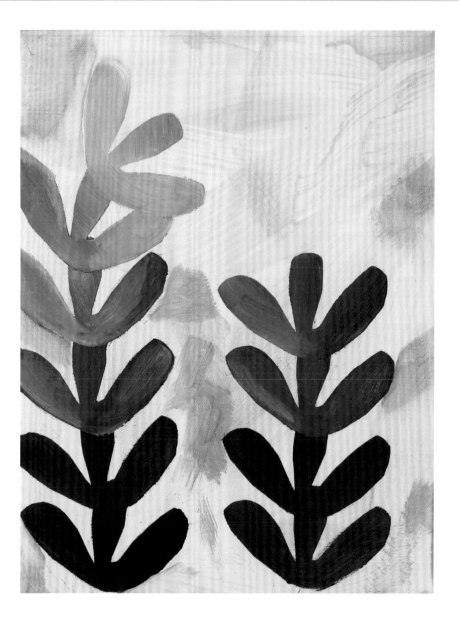

The Guide [2012] Oil on canvas. 40 x 31cm

EMILIE LUNDSTRØM

GRADUATED: GLASGOW SCHOOL OF ART

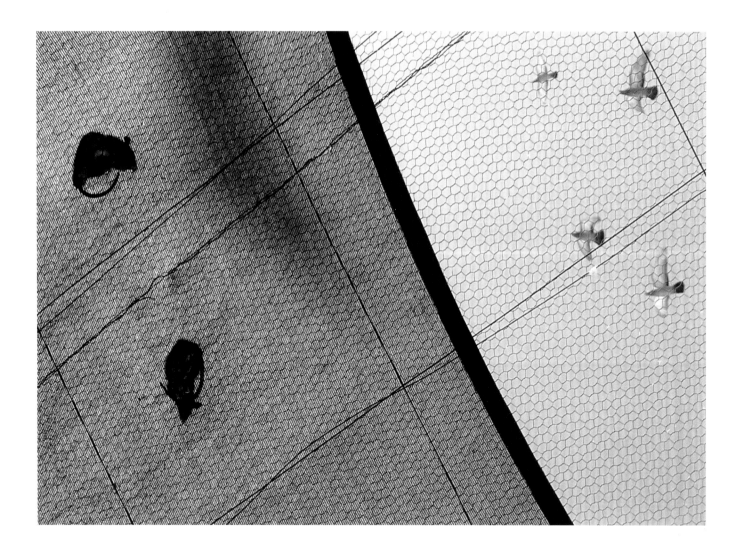

Slow-wawe Sleep [2012] Photo on canvas. 130 x 200 cm

AMY MALCOLM

GRADUATED: GLASGOW SCHOOL OF ART

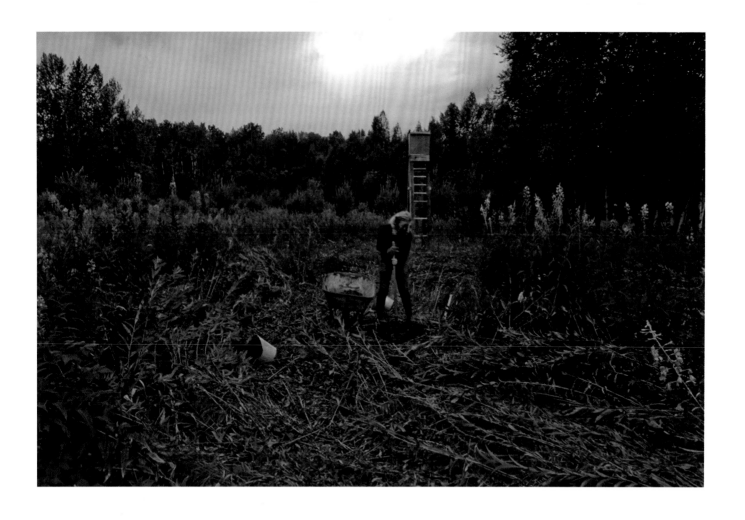

Mining Alaska [2011] Red wood, railway sleepers, sheet metal, earth. Photography Chuck Chaney

MICHELLE ROBERTS

GRADUATED: GLASGOW SCHOOL OF ART

On Ore II & III [2011] Wax with hand ground etching ink. Each panel 123 x 81.5 x 2cm

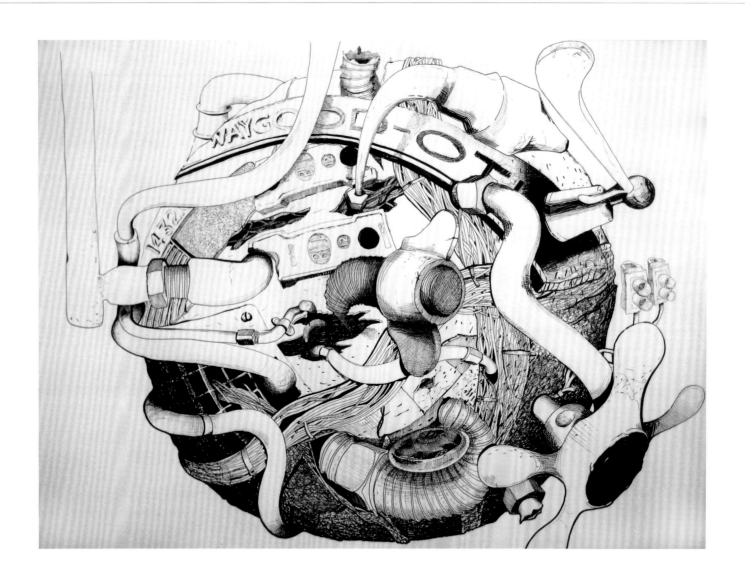

Kelly Conglomerate [2009] Pen on paper. 118.9 x 84.cm

MARY STEPHENSON

GRADUATED: GLASGOW SCHOOL OF ART

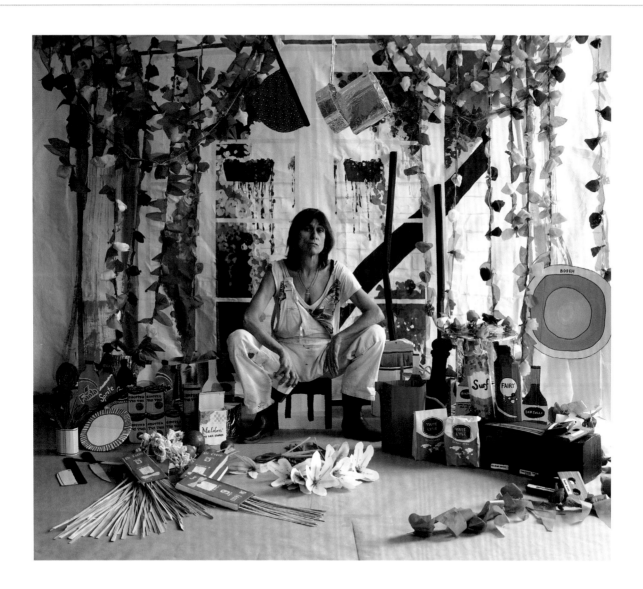

Mum [2011] Inkjet Print on Somerset Enhanced paper, Framed. 115 x 125cm

EVA ULLRICH

GRADUATED: GLASGOW SCHOOL OF ART

Untitled 4/11 [2011]
Oil on Canvas. 125 x 150cm

GRAY'S SCHOOL OF ART
ROBERT GORDON UNIVERSITY, ABERDEEN
FOREWORD BY IAIN IRVING

ARTISTS

Lindsey Clark

Hannah Harkes

Marion Leiper

Joanna Lyczko & Seila Susberg

Heather Pugh

Sophia Katie Scott

Susannah Stark

Chris Wells

GRAY'S SCHOOL OF ART

IAIN IRVING, MA COURSE LEADER AND UG CRITICAL AND CONTEXTUAL LECTURER

What are they making in there?

There is an artist's studio near my house. It was once a Watch House. And still, it sits quietly on the cliff edge looking out over the North Sea. I occasionally walk along the coastal path that leads to it and as it flows you into the garden, you think, "What a beautiful place."

It has a gracious air; somewhere to retreat to, to slow down, to take time and meditate on art and life. But sometimes there are noises - big echoey noises: sawing, cutting, a constant scraping, a heavy banging or the sound of singing wildly out of tune. Then there are glimpses of movement, the arching of an arm, a frantic walking up and down, a slowing of pace in focused concentration. There is also rich colour and dazzling light that changes as the day goes. When I pass-by it's always different and I think: what are they making in there?

As I walk around Gray's School of Art, I catch glimpses of activities I have seen at the artist's studio - same sounds, similar movements, a constant attention to creativity. The healthy art school environment is one that appears chaotic, shambolic, experimental but undoubtedly idiosyncratic. Each year I see empty studio spaces become selected and occupied, found materials and specialist equipment being carried in, things built, space becoming rare, gears changing and pennies dropping. There are ebbs and flows of activities throughout the year that manage and manipulate the ideas and processes of the students who, like creative midwifes, nurture and soothe art from the chaos. Making art is a metaphorically noisy, messy and arduous process and there is a lot of art being made that we never really see. We might hear it, smell it, taste it. It's in the air, but it's a rare thing to see it being made. We might only catch a glimpse of the effort and concentration that takes place. Making art is a personal endeavour, not just practice for

a public showing. Every task and endeavour encompasses a merging of this chaos and order, so showing in public, live, to an audience, seems risky and at odds with the intentions and purpose.

This process is important for the art maker. They take risks, challenge the aesthetic, and are sensitive with the materials, conscious of the outcomes. Take note of this intense process while able to see the whole picture, while you move around the exhibition, in encountering a section of artwork from this year's Gray's School of Art students - Lindsey Clark, Hannah Harkes, Marion Leiper, Heather Pugh, Sophia Scott, Susannah Stark, Christopher Wells, Seila Susberg and Joanna Lyczko in this RSA Contemporaries Exhibition. These young artists are not only showing us their images and objects, they are publicly sharing with us the experience of their making. Some have completed the artwork for us to see and interpret, while others encourage us to be part of this continuous process of making, even as we see, even as we watch and glimpse elements of the art in progress.

It now seems significant that these (and many other) artists are challenging the symptomatic convention of the Modernist art exhibition experience. The exhibition (and its attendees) nurtures the experience that changes with our senses and our needs. Art may have always wanted to do this but, as Alain de Botton has recently pointed out:

'[We are in a situation in which] modern museums of art fail to tell people directly why art matters, because modernist aesthetics... are so deeply suspicious of any hint of an instrumental approach to culture. To have an answer anyone could grasp as to the question of why art matters is too quickly viewed as "reductive". We have too easily swallowed the

modernist idea that art that aims to change or help or console its audience must by definition be "bad art"... and that only art that wants nothing of us can be good. Hence the all-too-frequent question with which we leave the modern museum of art: what did that mean?'[1]

Therefore what is being pursued here is the artist's ambition for the artwork to be encountered in the formal space but also to significantly enable the viewer to have a prerogative sense of meaning and empathy with the artwork. The artists here want their work to be fully experienced and interpreted; they want you to experience the claustrophobic nature of enclosures (Lindsey Clark), sneak-a-peek at the artist at work (Hannah Harkes), be entranced by the anthropomorphic stereotypes (Marion Leiper), contemplate the transformation of devalued objects (Heather Pugh), be unnerved by issues of censorship (Sophia Scott), feel the rhythm of 'making' (Susannah Stark), revere the inherently uncanny and 'out-of-placeness' of things (Seila Susberg & Joanna Lyczko) or simply enjoy the representations of the artists' thoughts at a particular moment (Christopher Wells). It is as important to them that you care for what you see as much as they have done throughout the artwork's gestation.

Meanwhile back outside the artist's studio it is quiet, the air has settled, the light is lowering and all seems well. Perhaps another artwork has been made, ready to be seen.

..

[1] De BOTTON, A., 2012.
Comment is free - Should art really be for its own sake alone? [online]. London: The Guardian. Available from: http://www. guardian.co.uk/commentisfree/2012/jan/20/art-museums-churches?INTCMP=SRCH [Accessed 24 January 2012].

LINDSEY CLARK

GRADUATED: GRAY'S SCHOOL OF ART

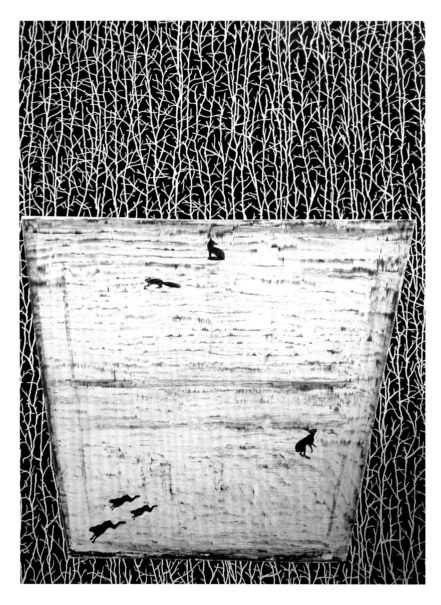

**I thought that nobody
was in the wood but me** [2010]
Oil on board. 122 x 166cm

HANNAH HARKES
GRADUATED: GRAY'S SCHOOL OF ART

Granite, Key, and Offal [2011]
Pencil on paper. Each image 29.6 x 20.3cm
Photography Pablo Laune

MARION LEIPER

GRADUATED: GRAY'S SCHOOL OF ART

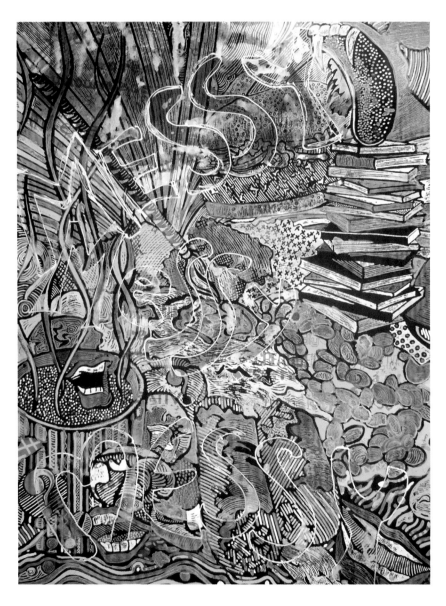

Messy [2011]
Woodcut/Screenprint
112 x 80cm

JOANNA LYCZKO & SEILA SUSBERG
GRADUATED: GRAY'S SCHOOL OF ART

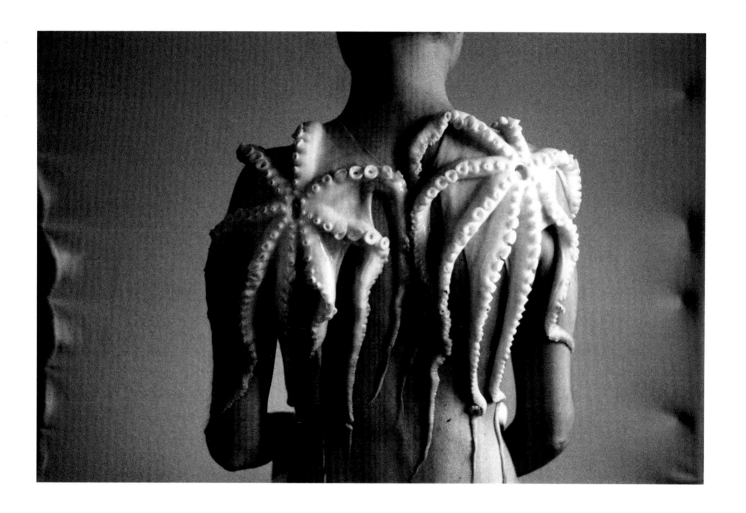

Octopi [2011] Photography, fine art print. 60 x 80cm

HEATHER PUGH

GRADUATED: GRAY'S SCHOOL OF ART

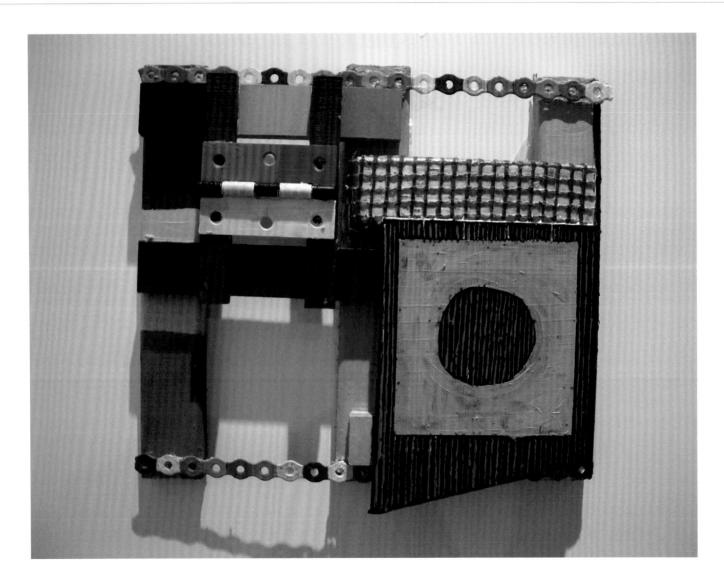

Batten Down the Hatches [2011] Mixed media. 30 x 21cm

SOPHIA KATIE SCOTT

GRADUATED: GRAY'S SCHOOL OF ART

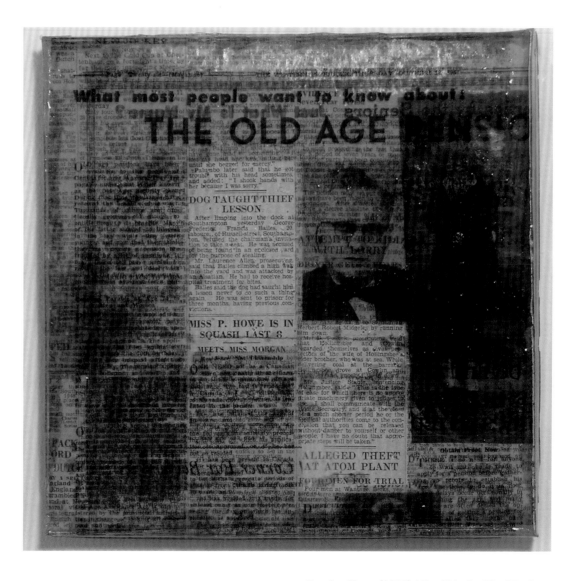

Pension Times [2011] Mixed Media. 23 x 23 x 5 cm

SUSANNAH STARK

GRADUATED: GRAY'S SCHOOL OF ART

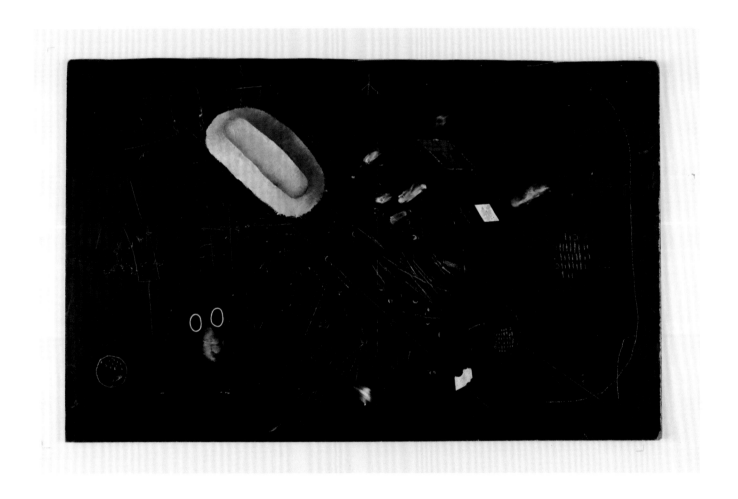

pols voice [2010] Oil paint on board. 38 x 30.5cm. Photography Stuart Johnstone

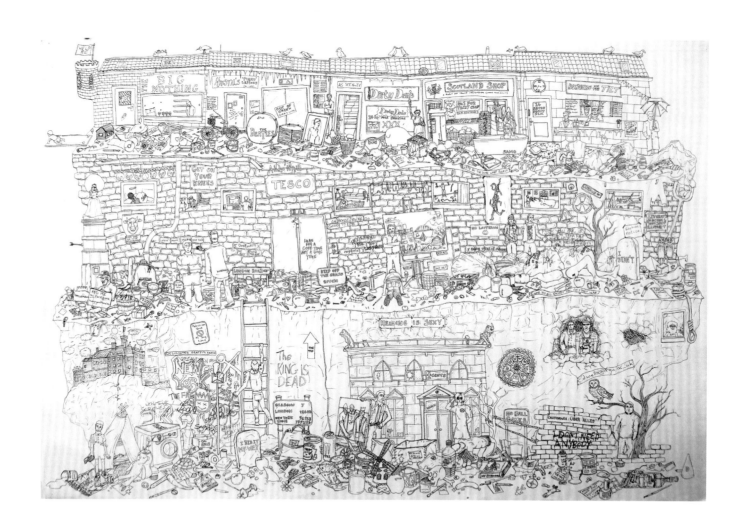

Mr Dylan Has Gone Walkabout [2011] Ink on Paper. 84.1 × 118.9cm

MORAY SCHOOL OF ART

MORAY COLLEGE, UNIVERSITY OF THE HIGHLANDS & ISLANDS, ELGIN

FOREWORD BY GINA WALL

ARTISTS

Marnie Keltie

Deborah Macvicar

MORAY SCHOOL OF ART

GINA WALL, CURRICULUM LEADER

The artists selected from Moray School of Art for *RSA New Contemporaries* 2012 hint at the growth of the fine art degree since the introduction of the distance learning pilot in 2009/10. This learning model has enabled students to complete their studies in fine art whilst remaining resident on the Outer Hebrides. The distance learners from the graduating cohort of 2010/11 began the degree programme with Lews Castle College UHI, working out of the award winning museum and Arts Centre *Taigh Chearsabhagh*. Upon completion of a Diploma in Higher Education, the students transferred to Moray School of Art as distance learners.

Insofar as the distance learning blend uses a range of technologies to connect dispersed learners it exemplifies the mission and rationale of the University of the Highlands and Islands. Namely, to use all of the educational means at the disposal of the institution to offer learners ways to enrich their lives and contribute to the communities which mean so much to them. However, we should not forget that in offering others the opportunity to develop, we open out to change ourselves. The distance learning project is a case in point. By seeking ways of making learning more accessible we have found new and innovative ways of working which have challenged, yet enriched, our approaches to learning and teaching.

Both of the artists selected for this year's 'New Contemporaries' are resident in *Na h-Eileanan Siar* and although they both work with ideas that are closely connected with their environment, there are some clear divergences. Marnie Keltie's painting practice is principally concerned with process and the extent to which we can find analogies between painting and environmental processes. For example, the shifting of sand on a beach, the movement of the shoreline as we are pulled around the sun, and the revelation of new textures after stormy seas. The temporal nature of landscape permeates Keltie's

work; from the early pieces which engaged with the sea quite directly (literally using the tide to move the paint around the canvas), to the works on show at the RSA which consider the sea in different terms.

The wall piece has been painted directly onto plaster using pigments made from materials collected on Baleshare beach, North Uist. These materials are meticulously ground and the pigment is mixed in egg tempera to make a soft and yielding surface which relocates elements from the beach within the gallery space. This notion of moving something from one place to another is also picked up by her piece *Dislocation*. Using the motif of the American lobster pot tag, this work speaks of the power of the sea to transport flotsam from one side of the Atlantic to another. These little plastic artefacts, whose provenance Keltie has traced, act as ciphers for migration and dispersal and they remind us that our seas are vast, with unknown pulls and currents. Perhaps tellingly, *Dislocation* invites us to reflect on the idea that everywhere is island. The sea acts as a conduit and connector between our collective island; an involuntary transporter of waste which can be both magical and terrible. Keltie's intensive engagement with a small stretch of beach at Baleshare results in a contemplative enquiry into the way in which painting can articulate those bigger concerns about the come and go of our planet: concerns which walking on a beach at the very edge of Europe can bring to mind. Whilst Keltie's work investigates painting processes, and expresses something of the landscape under constant environmental transformation, Deborah MacVicar's practice engages with landscape quite differently. The interaction between artist and landscape might be described as performative; that is through her performance based films, cyanotypes and explorations of notions of animal, the artist-self is performed by landscape.

If we reflect momentarily on what Judith Butler states about gender construction with respect to performativity, we can see that it bears a relation to one of the strategies of MacVicar's practice. Butler famously argues that 'gender is in no way a stable identity or locus of agency from which various acts proceed...it is...an identity instituted through a *stylized repetition of acts.*' (Butler, 1988: 519) For Butler, gender is performative insofar as the illusion of a stable gender is constructed from the repetition of mundane acts which demonstrate societal expectations of each respective gender. She argues that breaking with these coded performances, by repeating gender acts in a subversive way, is the only possibility for transforming or rupturing gender stereotype. Although MacVicar is not directly concerned with questions of gender, Butler's ideas about performativity resonate with the artist's desire to explore the liminality between animal and human.

MacVicar's filmed performances record the landscape as an arena in which the relation between animal and human is constituted. The artist performs a series of subversive acts, in which she assumes animal behaviours in order to question the human conception of ourselves as distinct from the animal world. The inclusion of footage of a living deer opens a space in which the artist and animal can begin to relate to one another. However, our significant impact upon the world of the deer is underscored by the inclusion of the hides which sit just in front of the film in the gallery. As the film runs, the light from the projector plays across the hair casting a shadow across the screen. These hides are a combination of the Red and Sika Deer which are stitched together making reference to the hybridisation of the Red Deer population in Scotland. However, we should be cautious in our interpretation of this: it is not a retrograde plea for purity and conservatism, but a reminder of the ways in which we transform, but at the same time are transformed by, the landscapes in which we live. As Tim Ingold writes:

'As the familiar domain of our dwelling, [landscape] is with us, not against us, but it is no less real for that. And through living in it, the landscape becomes part of us, just as we are part of it.' (Ingold, 1993: 154)

There are certainly times when the weather is so severe in *Na h-Eileanan Siar* that it would cause us to question what Ingold says about landscape being with rather than against us. However, we can see from the work of both of these artists that living in this landscape is transformative. In Keltie's case, landscape is a process: the small stretch of beach a surface upon which changes are constantly inscribed. For MacVicar, the landscape transforms the artist-self, placing her under-erasure. Identity is called to question: by undertaking a practice which explores 'the possibility of a different sort of repeating' (Butler, 1988: 520) MacVicar allows herself to be reconstituted.

Distance learning at Moray School of Art is no longer a 'pilot' but an accepted alternative to face-to-face delivery. Our distance learners bring a new dimension to life at the school and we look forward to its continued development. As for the artists chosen for 'New Contemporaries' 2012, I hope that the more testing aspects of degree study at a distance have helped to prepare them for life as a practising artist. They go onward into that particular challenge with our very best wishes.

References:

Butler, J. (1988) Performative Acts and Gender Constitution: An Essay in Phenomenology and Feminist Theory, *Theatre Journal*, 40:4 519-531

Ingold, T. (1993) The temporality of the landscape, *World Archaeology*, 25:2 152-174

MARNIE KELTIE

GRADUATED: MORAY SCHOOL OF ART

Dislocation (installation detail) [2011] Oil on canvas and board with cut and cast paint. Each panel 10 x 10 x 2cm.

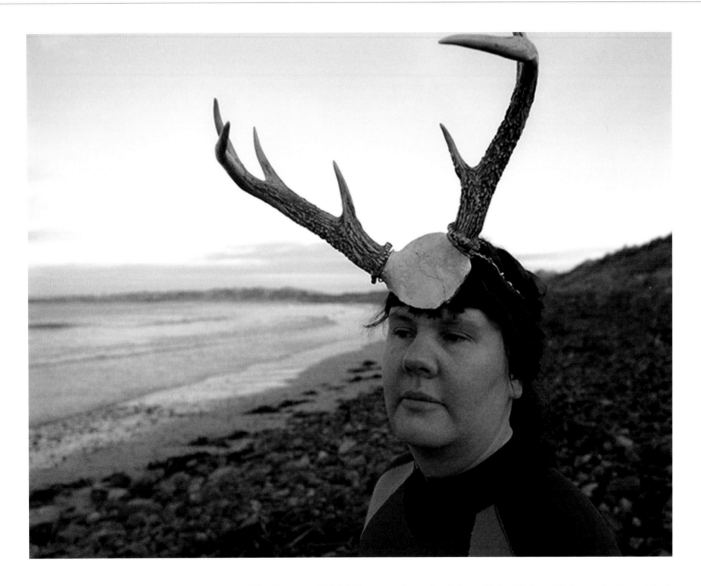

Sika deer stag [2012] Photograph on aluminium. 25.4 x 20.3cm. Photography Anne Monk

ARCHITECTURE

DUNDEE SCHOOL OF ARCHITECTURE
UNIVERSITY OF DUNDEE
Luca Di Somma

EDINBURGH COLLEGE OF ART
Scott Licznerski

THE EDINBURGH SCHOOL OF ARCHITECTURE AND LANDSCAPE ARCHITECTURE
(ESALA), THE UNIVERSITY OF EDINBURGH & EDINBURGH COLLEGE OF ART
Sarah Clayton & Gillian Storrar
Andrew Morris

MACKINTOSH SCHOOL OF ARCHITECTURE
GLASGOW SCHOOL OF ART, UNIVERSITY OF GLASGOW
Martin Flett

THE SCOTT SUTHERLAND SCHOOL OF ARCHITECTURE
AND THE BUILT ENVIRONMENT, ROBERT GORDON UNIVERSITY
Daria Byra
Rowan Morrice

THE UNIVERSITY OF STRATHCLYDE DEPARTMENT OF ARCHITECTURE
Abigail Benouaich

LUCA DI SOMMA

GRADUATED: UNIVERSITY OF DUNDEE

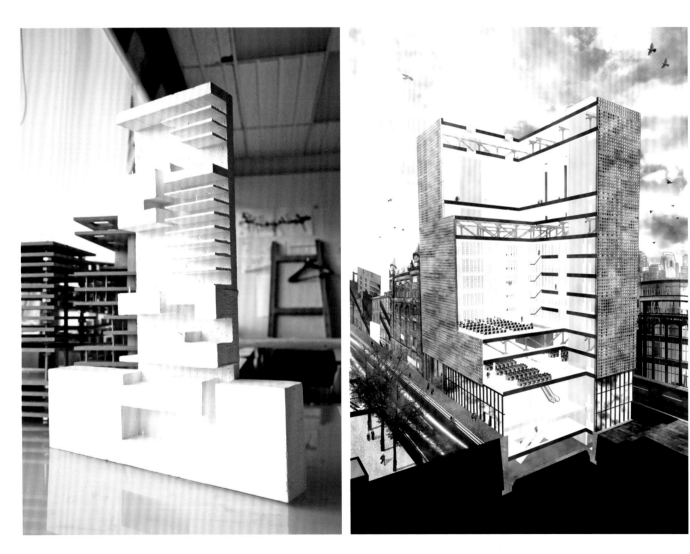

The Liberation of Space [2011]
Images from left: Model of the Arrangement of Spaces at 1.200, white plaster; Perspective Sectional Diagram, photoshop/sketch up.

SCOTT LICZNERSKI
GRADUATED: THE EDINBURGH COLLEGE OF ART

The Depository of Memory [2011] Rendered photograph

SARAH CLAYTON & GILLIAN STORRAR

GRADUATED: THE EDINBURGH SCHOOL OF ARCHITECTURE AND LANDSCAPE ARCHITECTURE

Mediating Infrastructure. Training vessel and exhibition vessel embedded in the mediating surface [2011] CAD Drawing. 60 x 38cm.

ANDREW MORRIS

GRADUATED: THE EDINBURGH SCHOOL OF ARCHITECTURE AND LANDSCAPE ARCHITECTURE

[re]Constructed Ground, The Value of Material Objects [2011] Grey modelling card, wood and plaster. 15 x 15 x 26cm.

MARTIN FLETT

GRADUATED: MACKINTOSH SCHOOL OF ARCHITECTURE

Venice Terme [2011] Interior view of hamam tepidarium. Photograph of physical model.

DARIA BYRA

GRADUATED: SCOTT SUTHERLAND SCHOOL OF ARCHITECTURE & BUILT ENVIRONMENT

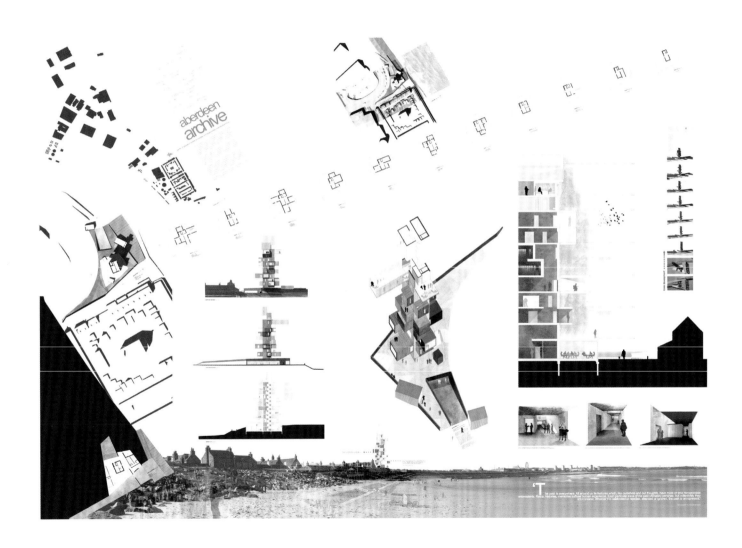

Peripheral Vision - Archive Tower in Aberdeen (full Presentation) [2011]

ROWAN MORRICE

GRADUATED: SCOTT SUTHERLAND SCHOOL OF ARCHITECTURE & BUILT ENVIRONMENT

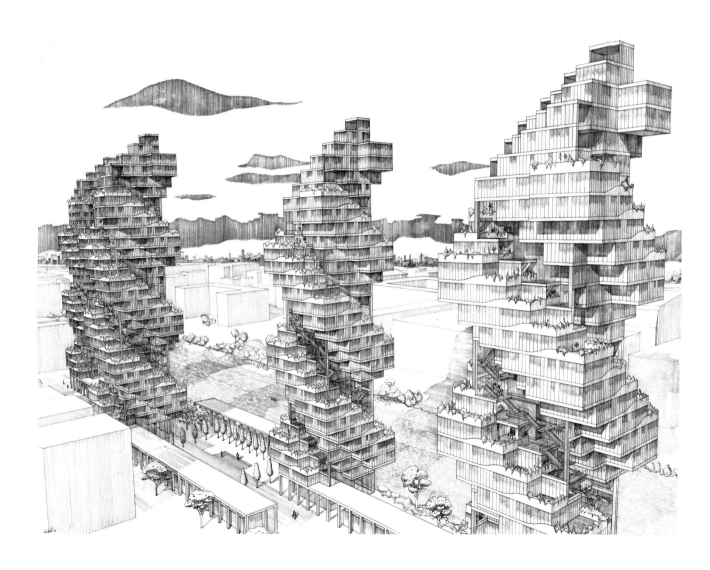

High rise residential, Four Towers [2011] Ink on tracing paper. 76 x 102cm.

ABIGAIL BENOUAICH

GRADUATED: UNIVERSITY OF STRATHCLYDE

Evolving Density - Quartier Spagnoli. Rooftop relocation pilot strategy for 40 family target [2011] Watercolour. 21 x 29.7cm.

RSA:NC AWARDS

DAVID & JUNE GORDON MEMORIAL TRUST AWARDS
For artists born or studying in the Grampian region.

EDINBURGH PRINTMAKERS AWARD
For a printmaking course, 3 months associate membership and 1 month's free use of the studio.

**EDINBURGH SCULPTURE WORKSHOP
GRADUATE RESEARCH AWARD**
A residency for one month in one of the ESW's project spaces including a fee of £150 for production costs, training and support, the opportunity for a public event and free membership for one year.

GLASGOW PRINT STUDIO AWARD
Invitation to have a print co-published with the Glasgow Print Studio.

PEACOCK VISUAL ARTS AWARD FOR MOVING IMAGE
For six months free access to Peacock's digital facility.

THE SKINNY AWARD IN ASSOCIATION WITH CCA
A selected artist will receive a multi-platform award including guaranteed exposure in The Skinny magazine's Showcase in print and online, and an exhibition in Glasgow's CCA in spring 2013. The Skinny also provides a bespoke launch event and accompanying publicity campaign for the exhibition.

[£5000] **THE STEVENSTON AWARD** for a painter of merit
The Stevenston Charitable Trust was established in 2000 with the particular aim of supporting the advancement of the arts, culture and heritage, and in particular, promoting access to the arts by young people in the Lothians and Borders regions of Scotland.

[£2000] **RSA SIR WILLIAM GILLIES BEQUEST AWARD**

[£500] **FRIENDS OF THE RSA AWARD** for any category

[£400] **RSA ART PRIZE** plus the Maclaine Watters Medal

[£400] **RSA ART PRIZE** for any category

[£400] **RSA ARCHITECTURE PRIZE**

[£200] **RSA CARNEGIE SCHOLARSHIP** for painting

[£150] **RSA ADAM BRUCE THOMSON AWARD** for any category

[£150] **RSA LANDSCAPE AWARD** for a drawing, oil or watercolour

[£150] **RSA CHALMERS BURSARY** for any category

[£150] **RSA STUART PRIZE** for any category

[£150] **RSA CHALMERS-JERVISE PRIZE** for any category

INDEX OF ARTISTS

If you wish to get in touch with any of the artists from this exhibition, please contact the Royal Scottish Academy:

The Royal Scottish Academy
The Mound, Edinburgh
Telephone: 0131 624 6556
Email: info@royalscottishacademy.org
www.royalscottishacademy.org

ACKNOWLEDGEMENTS

RSA NEW CONTEMPORARIES 2012

The Royal Scottish Academy would like to thank Joanna Lyczko and Seila Susberg for use of their image to publicise the exhibition. Thanks also to the Hanging Committee: Glen Onwin RSA (Convener), Kathryn Findlay RSA (Elect) (Depute Convener), Eileen Lawrence RSA, Jacki Parry RSA, Gareth Fisher RSA, Francis Convery RSA, the Exhibition Staff and Neil Mackintosh and his team for their work in presenting the show. Also thanks to the staff of the Art Colleges and Architecture Schools in Scotland for their invaluable input and support. Thanks to Stuart Mackenzie and Mick McGraw, Gina Wall, Iain Irving, Stuart Bennett, Moira Payne and Glen Onwin RSA for their illuminating essays for the publication.

Also thanks to the external prize-givers: The Stevenston Trust; The Friends of the RSA; The David & June Gordon Memorial Trust; Peacock Visual Arts; Edinburgh Sculpture Workshop; Edinburgh Printmakers; Glasgow Print Studio and The Skinny Award in association with CCA.

We wish to extend a very special thanks to our main exhibition sponsor, Turcan Connell; our Media Partners, The Skinny; and also exhibition supporters Experian, the global information company. Thanks also to Drambuie and Thistly Cross Cider for their support of the *RSA New Contemporaries* opening reception.

Finally, a thank you to all the participating exhibitors – we wish you well for the future and hope that you will remain in touch with us as your careers continue to progress.

Administration by Colin R Greenslade, Jane Lawrence, Alisa Lindsay, Susan Junge, Andrew Goring, Gail Gray, Pauline Costigane, Emma Pratt, Mary Pathmanathan. Exhibition Staff: Rachael Bibby, Catriona Black, Harriet Brooker, Amy Cameron, Sandra Collins, Jessica Kirkpatrick, Dorothy Lawrenson, Emma Macleod, Geri Loup Nolan, Joel Perez Negrin, Francesca Nobilucci, Olga Rek, Hannah Rye and Derek Sutherland.

Published in the United Kingdom by the Royal Scottish Academy of Art & Architecture
for the exhibition *RSA New Contemporaries*, 17 March - 11 April 2012
The Royal Scottish Academy of Art & Architecture,
The Mound, Edininbrugh, EH2 2EL

Catalogue designed by Alisa Lindsay. Printed by 21 Colour.
Cover image: Joanna Lyczko & Seila Susberg 'Octopi' (detail)

ISBN 978-0-905783-23-9

Exhibition Sponsor

 Media Partner